TO:

FROM:

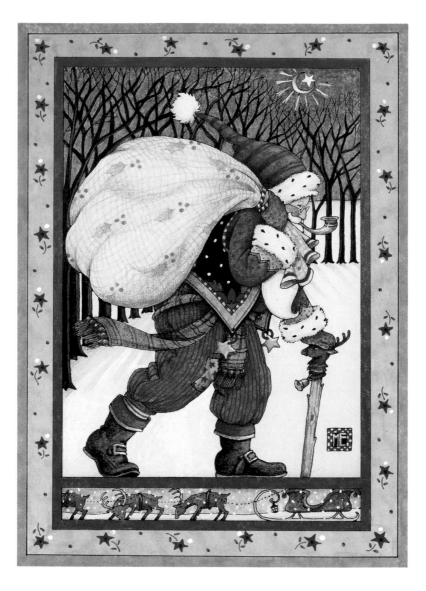

Believe

Illustrated by
Mary Engelbreit

Andrews and McMeel
A Universal Press Syndicate Company
Kansas City

 is a registered trademark of Mary Engelbreit Enterprises, Inc.

20 19 18 17 16 15 14 13 12 11

ISBN: 0-8362-4607-1

Library of Congress Catalog Card Number: 92-75636

Written by Jan Miller Girando

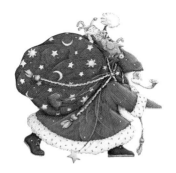

Believe

Everyone can be a child
at Christmas . . .

MERRILY · MERRILY

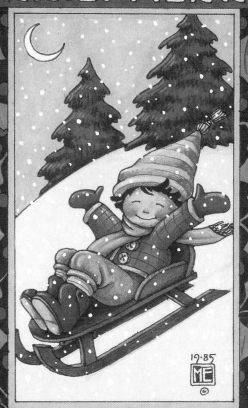

19·85
ME

MERRILY · MERRILY

Everyone can celebrate
with glee . . .

ON CHRISTMAS PLAY AND MAKE GOOD CHEER FOR CHRISTMAS COMES BUT ONCE A YEAR!

Everyone can make a
Christmas wish list . . .

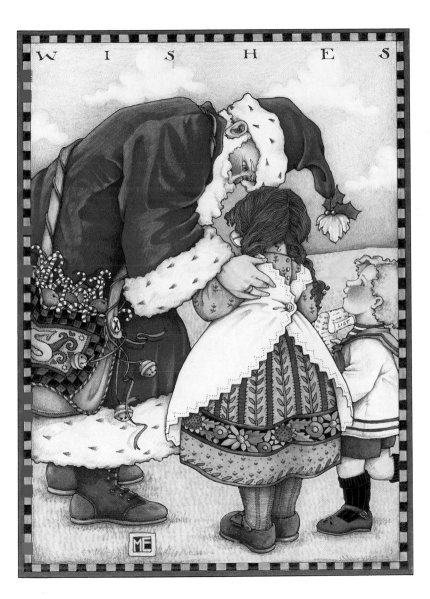

. . . and gather 'round
to decorate the tree.

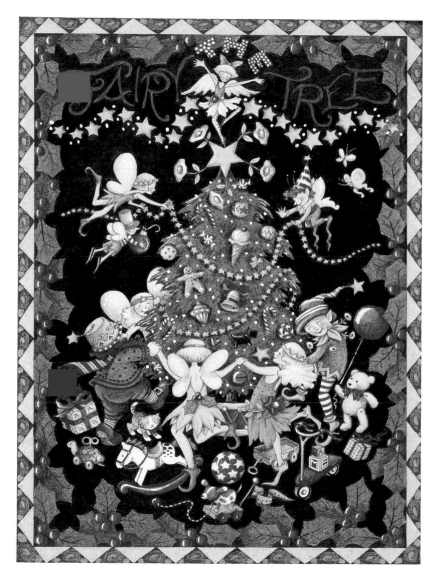

Everyone can watch
for Santa's helpers
darting in and out
as good elves should . . .

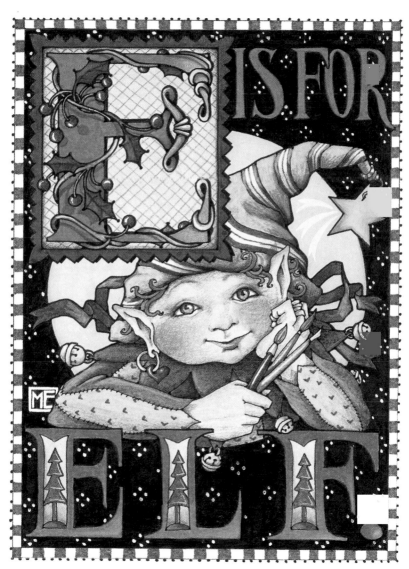

IS FOR

ELF.

. . . telling Santa Claus
 if we've been naughty . . .

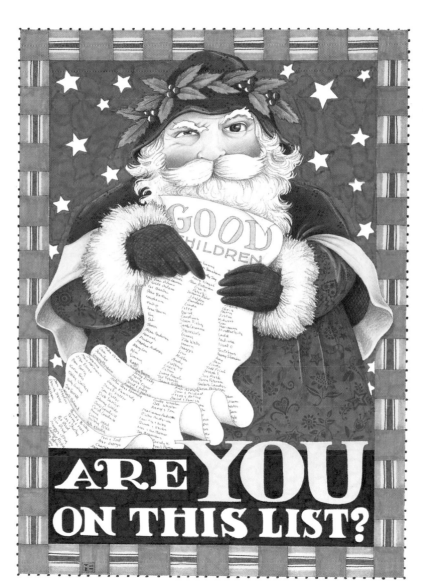

GOOD CHILDREN

ARE YOU
ON THIS LIST?

. . . letting Santa know
if we've been good!

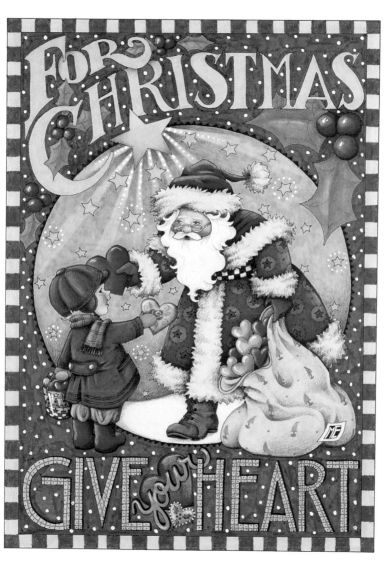

Everyone can wonder
at a snowfall
blanketing the hills
in winter white . . .

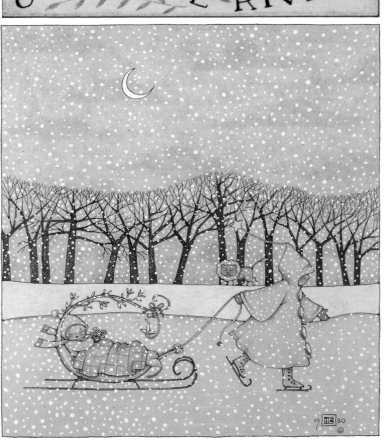

OVER THE RIVER

THROUGH THE WOODS

. . . and enjoy the spirit
of the season . . .

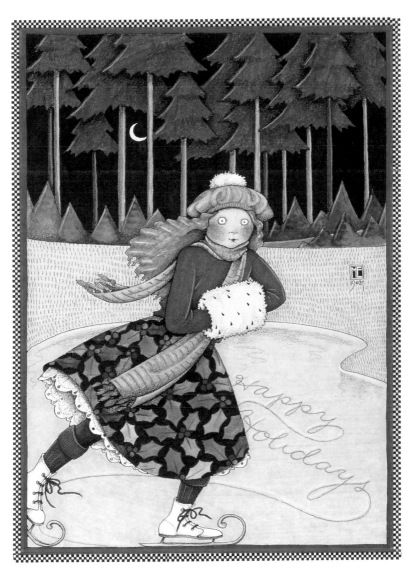
Happy Holidays

. . . or the moonglow
on a silent night.

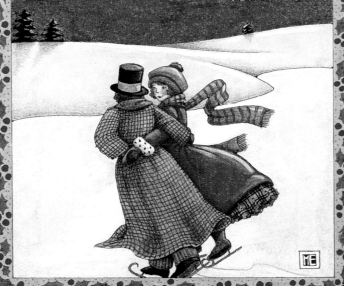

O! THE LEVEL LAKE
AND THE LONG GLORIES OF
THE WINTER MOON!

TENNYSON

Everyone can know
the special magic
of waiting for St. Nick
on Christmas Eve.

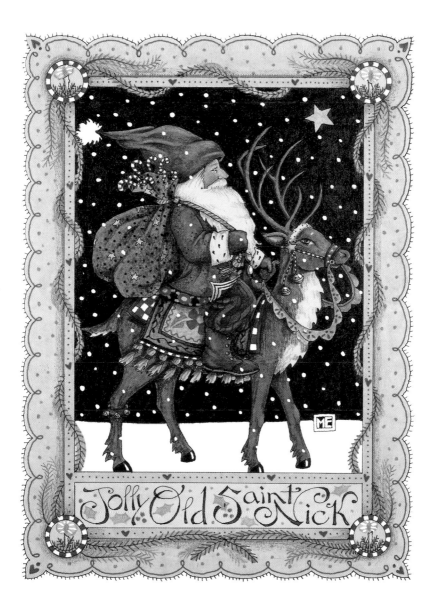

Jolly Old Saint Nick

Everyone can be a child
at Christmas . . .

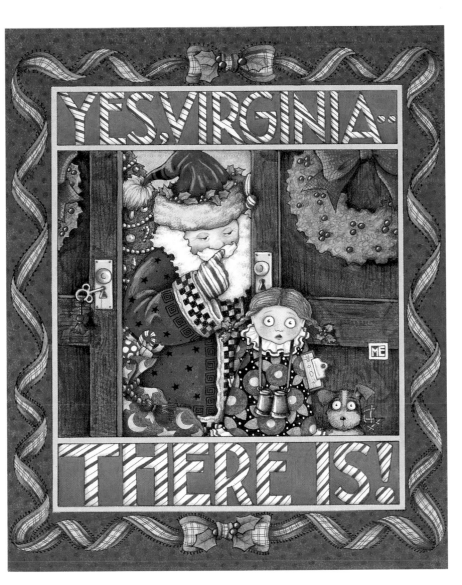

All we have to do
is just *believe*.

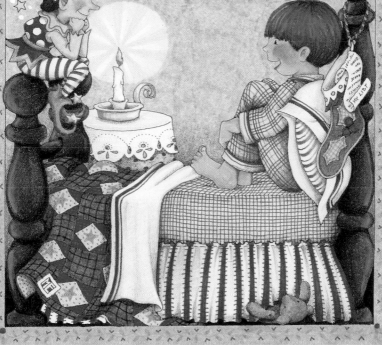

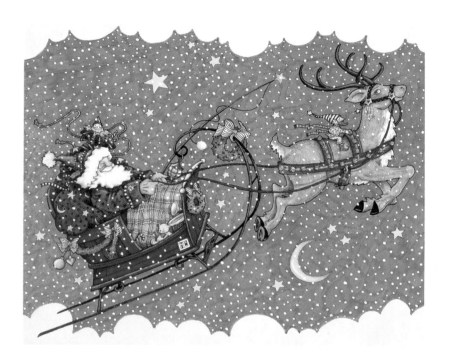